First published 2013 by order of the Tate Trustees by Tate Publishing, a division of Tate Enterprises Ltd, Millbank, London SW1P 4RG www.tate.org.uk/publishing

on the occasion of the exhibition
GARY HUME

Tate Britain
5 June – 1 September 2013

A catalogue record for this book is available from the British Library

ISBN 978 1 84976 143 7

Distributed in the United States and Canada by ABRAMS, New York

Library of Congress Control Number 2013933756

Designed by John Morgan studio

Colour reproduction by DL Imaging Ltd, London

Printed in China by Toppan Leefung Printing Ltd

Front cover: Gary Hume *Beautiful* 2002 (pl.*1*)

Measurements of artworks are given in centimetres, height before width

Photographic credits

Tate Publishing would like to thank the artist's studio; The Broad Foundation (photography Douglas M. Parker Studio, Los Angeles); Matthew Marks Gallery; Tate Photography/ Samuel Drake; and White Cube (photography Stephen White) for providing the photographs of works for this catalogue.

Copyright credits

Works by Gary Hume, Phillip King and Jeff Koons © the artist
Marcel Duchamp © DACS 2013
Richard Hamilton © the estate of Richard Hamilton

1995

*General Release: Young British Artists at Scuola di San Pasquale*, 46th Venice Biennale

*Minky Manky*, South London Gallery, London; Arnolfini, Bristol

*Brilliant! New Art from London*, Walker Art Center, Minneapolis; Contemporary Arts Museum, Houston

*The British Art Show 4*, Hayward Gallery, London; toured to Manchester, Edinburgh and Cardiff

*Wild Walls*, Stedelijk Museum, Amsterdam

*The Hanging Picnic*, Factual Nonsense, Hoxton Square, London

1994

*Unbound: Possibilities in Painting,* Hayward Gallery, London

1993

*Wonderful Life*, Lisson Gallery, London

*Lucky Kunst Part I*, Silver Place, London

1992

*New Voices: New Works from the British Council Collection*, toured to multiple venues in Europe and Russia (1992–97)

1991

*Broken English*, Serpentine Gallery, London

1990

*The British Art Show 3*, McLellan Galleries, Glasgow; Leeds City Art Gallery; Hayward Gallery, London

*East Country Yard Show*, East Country Yard, London

*A Painting Show: Michael Craig-Martin, Gary Hume, Christopher Wool*, Karsten Schubert Ltd., London

1989

Lorence-Monk Gallery, New York

1988

*Freeze: Part II*, Surrey Docks, London

Compiled by Melissa Blanchflower

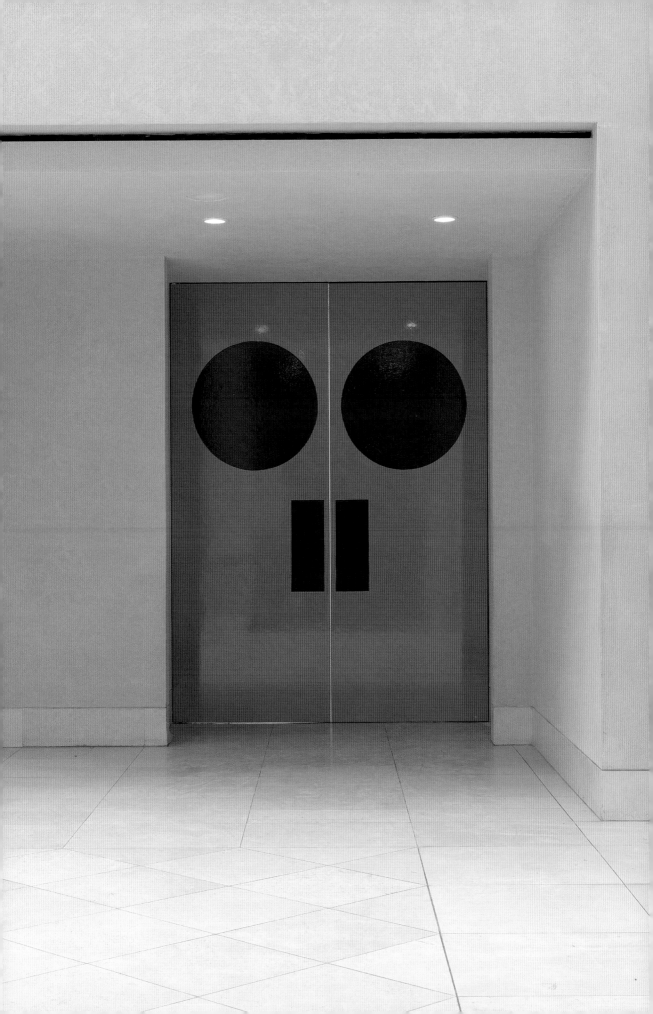

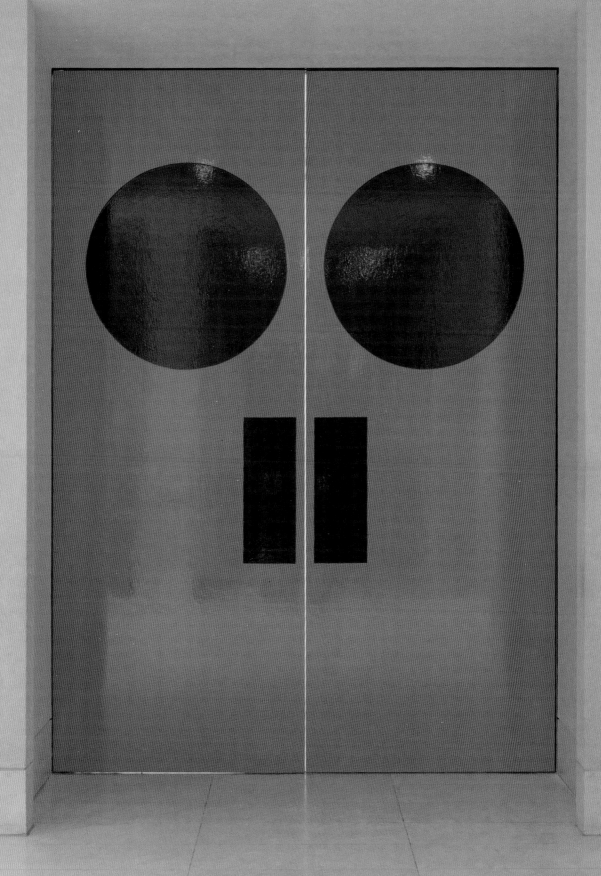

*Through to Innocence and Stupidity*

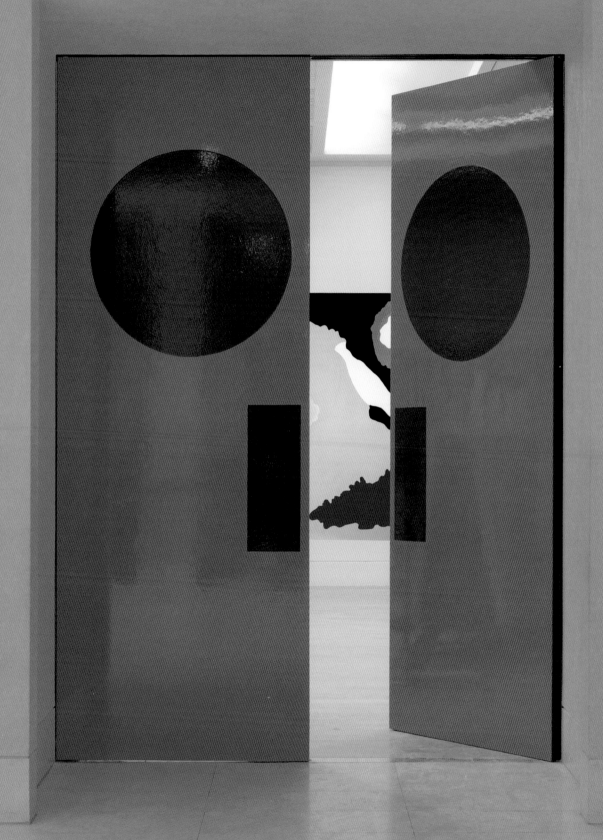

Edited by Katharine Stout

TATE PUBLISHING

# GARY HUME

# Foreword

Gary Hume has been making paintings for twenty-five years. From the outset the paintings had such assurance that their existence seemed indisputable. This has meant that their author too has enjoyed an autonomy that has allowed him to remain to one side of any grouping, however great the appeal of grouping artists together.

We are very pleased that Gary accepted our invitation to make this exhibition at Tate Britain, and that he has worked so closely with Katharine Stout on a show which is both broadly representative and highly selective, expected and unexpected. It covers the span of the artist's career but does more than this, in setting up judiciously controlled juxtapositions across the space of each gallery, revealing similarity and difference at every turn.

We are also delighted that Gary was ready for us to make this show alongside that of Patrick Caulfield, in a deliberate pairing of two artists whose works speak to each other and help us to see both better. Without wanting to make a forced comparison, we felt that Caulfield, whose work has always been there for Hume, would make for a neighbour who would not only reveal continuities in ways of making, but also in ways of seeing pictures. Their work reveals its complexity on acquaintance; each demands more time than you might expect on first encounter.

This exhibition has been made possible by the provision of insurance through the Government Indemnity Scheme. Tate Britain would like to thank HM Government for providing Government Indemnity and the Department for Culture, Media and Sport and Arts Council England for arranging the indemnity.

We are indebted to many private collectors who have lent works to the exhibition, as we are to the Bonnefantenmuseum, the Cranford Collection, the PinchukArtCentre and the Kunstmuseum Wolfsburg. Gary's galleries have been unfailingly helpful, as have his Studio Manager Kate Blake and assistants Zoe Griffiths and Kim Meredew. Philip Leeming and Leong Ong collaborated generously in designing special merchandise and John Morgan studio and Jack Bankowsky have greatly enhanced this catalogue. Many people within various teams at Tate Britain and at Tate Publishing have contributed to realising the exhibition and catalogue and their care and attention is evident throughout. I should like to acknowledge the thoughtfulness with which Katharine Stout and Melissa Blanchflower have overseen the project and, with Katharine, thank Gary for his great good humour and wisdom. Gary Hume makes beautiful pictures, and this exhibition reveals the range and nature of that beauty.

Penelope Curtis    Director, Tate Britain

Gary Hume    by Katharine Stout

Vibrantly colourful paintings modelled on the kind of swing doors found in hospital
and other state institutions allowed Gary Hume to develop a successful signature
style early in his career (fig.1). Recognisable for their round port holes and rectangu-
lar hand plates, the doors demanded a cool, pared-back treatment that was distinct
from the neo-expressionist and figurative painting that dominated during the
artist's student days in the 1980s. Hume's use of flat sumptuous colours to repre-
sent a precise distillation of form came to typify his ability to create paintings that
demand attention on their own terms rather than as representative windows onto
another world. He describes what it was about this ready-made geometric struc-
ture that attracted him:

> I could represent something which didn't in itself have a clear narrative,
> but onto which you could project your own narrative; and represent the
> actual thing in a painting by painting the actual thing. So this whole fiction,
> is it a door, or an image of a door. Is it a representation of a door, or is it
> an actual door that doesn't function? All those ideas were going on within
> minimalism in British sculpture. So the painting really fitted in there just
> beautifully. I'd found this jigsaw piece that could satisfy my need to paint,
> and my intellectual thoughts about art.[1]

Hume's downplay of the narrative content of his subject echoes Jasper Johns's
statement about his choice of the American flag, which he claimed came to him
in a dream: 'They seem to me pre-formed, conventional, depersonalised, factual,
exterior elements.'[2] Yet just as Johns's choices of flags, targets and maps now
seem loaded with meaning set against the political Cold War turbulence of 1950s
America, so Hume's decision to focus on hospital doors during a period when the
Conservative Government, led by Margaret Thatcher, was systematically cutting
funding for the National Health Service in Britain now seems poignantly to symbol-
ise the political ethos of the period. Ironically, it was an advertisement for private
health care that first suggested the subject to Hume – battered hospital doors
were used as an example of the rundown nature of the NHS.[3] Literally glossed over
with shiny decorating paint, Hume's painted doors can be interpreted as standing
for the gloss that the Conservative Government of the day was placing on the
private sector as the only viable alternative to a state-funded social welfare system.

Over twenty years after Hume abandoned his initial series of institutional
door paintings, *Red Barn Door* 2008 (pl.*17*) takes as its subject a classic American
red barn door to create a painting that is once again an object and a representation.
It contains both a reference to his early distinctive vocabulary and a deliberate
homage to American postwar abstract painting. 'I feel like I'm in conversation
with American art when I'm in America. I wanted to make a big "American" painting
and I wanted to talk about colour field and representation and Americana.'[4]

Since 2002, Hume and his wife, artist Georgie Hopton, have divided their time between their home in London and their farm in upstate New York. The exuberant bold colour of *Red Barn Door* is a direct response to the vernacular architecture in this area. Alongside this, the painting is also a confident reworking of the iconic motif that gave him great success three decades ago, and then for a brief period became a creative burden from which to escape.

For this exhibition at Tate Britain, Hume has also created bright pink-painted doors that are functional, taking to its logical conclusion Johns's dichotomy of whether a painting exists as a thing in the world or as a representation (see pp.3–7). Here it is both. *Yellow Window* 2002 (pl.*21*) can be seen to pay homage to Duchamp's reverse strategy of repurposing functional objects as art, in particular *Fresh Widow* 1920 (fig.2), a miniature replica of a standard French-style window painted turquoise blue, with each pane of glass covered with black leather. Described by the dealer Arturo Schwarz as a 'semi ready-made', this work by Duchamp offers an antecedent to the way in which Hume takes a pre-existing image or idea and customises it to make it his own.

From the mid-1990s, the subjectivity held at bay when Hume was painting a single motif began to creep into his wider choice of themes. Now his subjects are everyday dramas of birth and death, love and disappointment, vulnerability and strength, which emerge through series of paintings of 'flora, fauna and portraiture'.[5] There was also a noticeable shift in his palette around this time, as darker, more 'difficult' shades replaced the deliberately bland, universally pleasing colours selected for the doors as he turned to more personal subjects. The infant that peers out of the murky background in *Baby* 1994–5 (pl.*22*) exemplifies this bold resistance to beauty or easy aesthetic pleasure in the work. Behind the disturbing character of the painting, emphasised by its title written in reversed letters along the lower foreground of the image, lies an unusual honesty: it suggests the anxieties associated with becoming a parent. A later painting, *Older* 2002 (pl.*19*), also deploys muted blue tones to represent the female sitter as Hume imagined her in years to come. Initially conceived as a frontal pose, visible in the drawn outline beneath the layers of paint, the portrait has become an enigmatic featureless figure in profile, the gravitational aging of her body made apparent by the nipple highlighted on the elongated breast.

The lavish colours of Hume's floral paintings provide counterbalance to the more sombre tones found in his other works. Through a constant reinvention of this classic art-historical genre, Hume confronts a resistance to ornamentation that was a defining feature of early modernist art and architecture.[6] For him, there is an inherent tension in decoration that makes it compelling: 'It's horrific to know that we can find decoration beautiful, but then it is delicious to know that we can.'[7] Composed of intensely pink petals unfolding against a deep pool of warm chocolate brown, the painting *The Whole World* 2011 (pl.*4*) comprises a single blossom. The depicted flower becomes a vehicle for a carefully wrought negotiation of opulent colours and elegant forms that cohere to provide optimal visual pleasure.

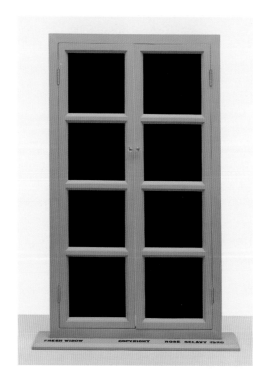

The pleasure of looking that they give the viewer reflects Hume's enjoyment of painting, in particular in harnessing the unique properties of household gloss paint that has become his trademark medium: 'with gloss paint you are always aware that the picture is just a thin film of solidified liquid. And I like that as some sort of analogy of the way you think of an image, picturing it in your mind's eye: coloured liquids pooling against each other.'[8] Despite the duskiness of the colour planes that make up the flower and its background, the painting appears to emit radiance. 'I don't use light', Hume has commented, 'Because that would be like painting space, so I use gloss paint to reflect light, to take real light.'[9] The painting is celebratory but also contains a sense of pathos. This tension echoes the lines by William Blake recalled by the painting's title, 'To see a world in a grain of sand, and heaven in a wild flower, hold infinity in the palm of your hands and eternity in an hour',[10] which refer to both the perfect moment and its inevitable passing.

A painting such as *Beautiful* 2002 (pl.*1*) both belies and confirms Hume's remark: 'All you get from me is surface', a claim that brings to mind Andy Warhol's similarly nonchalant statement, 'If you want to know all about Andy Warhol, just look at the surface of my paintings and me, and there I am. There's nothing behind it.'[11] The luscious and minimal surface of *Beautiful* evokes the fragility of beauty, an underlying concern that runs through Hume's portraiture. This is emphasised by his decision to superimpose Michael Jackson's now iconic nostrils as a black silhouette on top of the likeness of the British fashion model Kate Moss, which is subtly outlined within the flat plane of bright pink. Viewers encounter their own reflected faces at the same time as distinguishing Moss's likeness, drawn as a bas-relief in the paint, both images present on the surface of the painting. This work in particular highlights Hume's interest in the way the 'skin' of the gloss paint calls to mind the veneer of make-up, a comparison first described by Hume in 1999:

> In my new paintings, there's underpainting and then a surface layer of paint on top. In a way the underpainting is like the flesh and the surface on top is like makeup. What is the surface and what is the imagined surface? Where is the skin and where is the flesh? I find myself more and more interested in the use of makeup to cover flesh. Discovering where the hierarchies lie, what is above and what is below. How things meet.[12]

The camouflaged nature of Moss's portrait also hints at the ambition of celebrities to control the way in which their personalities are portrayed within our media culture. A fascination with those who reveal their vulnerabilities has often informed Hume's portrait choice – as seen for example in his depiction of radio DJ Tony Blackburn, who narrated his marriage troubles live on air (pl.*18*); Patsy Kensit, an actress better known for her turbulent love life (fig.3); and most recently the German Chancellor Angela Merkel, who has been thrust into the spotlight as a result of the euro crisis (pl.*23*). In 1967 Richard Hamilton similarly addressed the celebrity image at the point of public exposure in his painting, *Swingeing London,* which depicts Rolling Stones singer Mick Jagger in the back of a police car having

1.  *Incubus* 1991. Alkyd paint on Formica, 238.9 × 384.6, Tate
2.  Marcel Duchamp, *Fresh Widow* 1920 (replica 1964). Wood, metal, leather and Perspex, 78.9 × 53.2 × 9.9, Tate

just been arrested with art dealer Robert Fraser (fig.4). Unlike his pop predecessors, however, Hume does not focus on specific events but concentrates on depicting those whose misfortune makes them more engaging. Painted in 1993, *Tony Blackburn* is one of Hume's earliest forays into portraiture. Bearing no trace of his features, the work re-imagines Blackburn as a three-leaf clover rendered in matt dark purple paint set against a black disk, which contrasts with the cheerful colours surrounding it, creating a painting that is both intriguing and endearing.

The circular format of *Beautiful* refers back to the Renaissance tondo, a format frequently used in portrayals of the Madonna and Child, who for centuries also represented an archetypal definition of beauty. Typically, Hume's own version of this classic art-historical motif, *Young Mother and Child* 2001 (pl.3), draws attention to the humanity of the pair. The way in which the young mother grips the child's neck suggests an uneasy tension in the relationship, heightened by the unnatural colour scheme and somewhat ugly portrayal of the couple. A work painted the same year, *Two Minds* depicts a pair of slightly despondent figures that, as the title suggests, could be dual aspects of the same individual (pl.7). Silhouetted against pink gloss paint, multiple outlines of a girl drawn from different perspectives are submerged beneath a thin wash of matt orange paint. Three facial features on one of the distorted heads have been blacked out, enhancing the surreal tone of the painting. Hume's work often embraces melancholia; he has stated: 'I like things that are full of sadness, that have regret in them. If I can't see regret in a painting, then I think it's less than truthful.'[13]

Oblique references to works by artists as varied as Petrus Christus, Johannes Vermeer, Gustav Klimt and Ellsworth Kelly in his work reveal that Hume is well aware of the shoulders he is standing on when it comes to past 'giants' of painting. The relationship of his work to a recent history of painting is well documented in writing on Hume's work, but sometimes left out of the discussion are the British New Generation sculptors such as Phillip King, Tim Scott and David Annesley, who used bold, synthetic colour as a kind of skin to cover semi-geometric steel forms (fig.5). Their work shares a wit and irreverence with Hume's. Yet whilst Hume's paintings speak to many thematic and formal influences of the past, no direct lineage can be traced to a single figure. He creates works that combine the impact of formal abstraction with painting's historical ability to represent a world seen and imagined. Dave Hickey places Hume in the company of artists such as Patrick Caulfield, Wayne Thiebaud and Alex Katz, whom he describes as 'abstractionists of daily life', commenting: 'I think of these as servants of the moment, as purveyors of the domestic sublime and keepers of the day. In their work, the ethereal realm of modernist abstraction relaxes into the mundane circumstances of daily life.'[14]

Hume's varied compositions originate from images in historical art, photographs from magazines or newspapers and personal snapshots. He has described how he might come across an image in a second-hand book, instantly recognising it as 'a painting of mine',[15] which he then traces onto acetate and projects onto the wall. He adjusts and refines the image along the way, establishing the optimal scale

3. *Patsy Kensit* 1994. Gloss paint on panel, 208 × 117, Private collection
4. Richard Hamilton, *Swingeing London 1967* 1968–9. Acrylic paint, screenprint, paper, aluminium and metalised acetate on canvas, 67.3 × 85.1, Tate

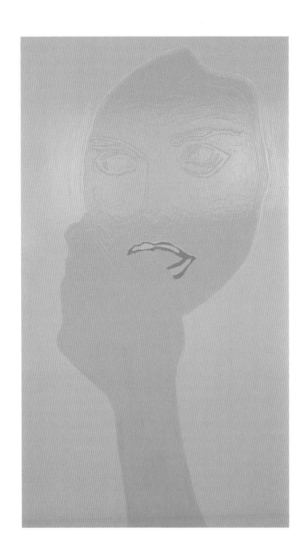

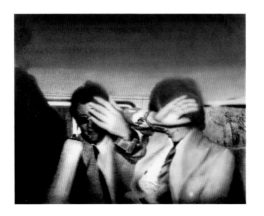

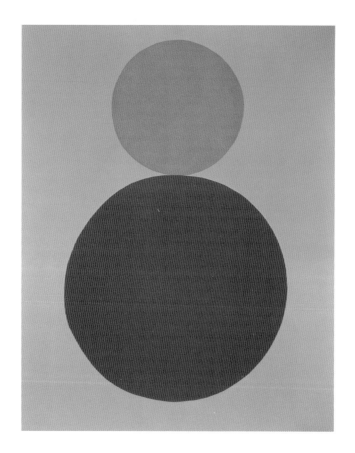

before transferring it onto an aluminium panel. From that point, he selects and shapes the areas of colour, which he describes as 'tectonic plates meeting',[16] to build the picture. Each colour sits on an even plane rather than suggesting foreground or background, resisting any illusion of pictorial space or perspective. The way in which the composition is assembled from abutting edges of saturated colour, rather than a linear outline, makes each painting identifiably Hume's. The final stage of a work is the act of naming, by which the painting is acknowledged as a complete autonomous object rather than something in the making, or as Hume has said, '[it] looks like it's always been there, rather than I've made it'.[17] Often a title might refer back to the original source or subject, causing the viewer to see afresh what first attracted Hume's interest.

There is often a disjuncture between a work's original inspiration and its realisation as a painting. The animal motifs for *Innocence and Stupidity* 1996 (pl.*2*) and the series of *Garden Paintings* (pl.*15*) painted the same year were prompted by an encounter with 'The Lady and the Unicorn' tapestries, displayed in the Musée de Cluny, Paris. Reminiscent of a Rorschach test, *Innocence and Stupidity* contains a mirrored image that the viewer might decipher as a young, carefree but simple-minded animal. Although innocence and stupidity can be considered naïve virtues, the binary opposition suggested by this painting signals the idea that each emotion or attribute invariably has its flipside of fallibility, a belief that informs many of Hume's paintings. There is also a childlike quality to *Garden Painting #3*, not only in its depiction of farmyard creatures, but also in the way that blades of grass are crudely represented by sticks of colour running along the bottom of the painting. In a similar way to the medieval tapestries that inspired this imaginative series of paintings, the metaphoric gardens portrayed suggest a private world of invented iconography.

Also evoking Hume's fascination with childhood is the recurrent subject of the snowman, which first appeared in 1996 in a painting of two perfectly formed coloured spheres (fig.6). What at first appears to be a play on geometric formalism is pulled out of the category of abstraction and into the realm of figuration by its title, *Snowman*. In 1997, Hume and his friend, the artist Don Brown, coloured snowmen they made with food dye and photographed them, releasing the images as an editioned print. Later, the subject offered Hume the impetus to start making work in three dimensions (pl.*16*). For him, 'The snowman is the perfect sculpture. Like the door was the perfect painting. It works entirely in the round: you're supposed to be able to travel around it and there are no dead zones.'[18] It is also an apt symbol of his ongoing quest to capture a fleeting moment in time, since 'What could be more perishable and more ephemeral than a snowman?'[19]

Whether in sculptures or paintings, and whether his focus is a person, animal or plant, Hume is constantly reinventing how he addresses the figure, creating visually playful shapes and compositions from body parts and outlines. He frequently investigates the way in which the body emits an emotional or sexual charge, or embodies the character of an individual. Throughout his work, a subject might start as one

5. Phillip King *Tra-La-La* 1963. Plastic, 274.3 × 76.2 × 76.2, Tate
6. *Snowman* 1996. Gloss paint on aluminium, 201 × 160, Private collection

thing and become something else in the making, as seen when he set out to depict his neighbour and friend in upstate New York, fellow painter Nicola Tyson. In this series of portraits, Hume's focus is both Tyson's striking visual appearance, characterised by her long, auburn hair partially covering her face, and the inner strength of her personality. *Green Nicola* 2003 (pl.*11*) captures the distinct features of Tyson's look, but instead of depicting her as a classic 'English Rose' or Pre-Raphaelite muse, she is portrayed using her hair as a cloak to hide from the world, emphasising the guarded nature of her character. Morphing her into a rare and beautiful flower, *Nicola as an Orchid* 2004 (pl.*9*) concentrates on her independent spirit, resilient and fragile at the same time. The burnished surface of the aluminium panel left bare and exposed softens the monumental stature of this large painting.

The large *Paradise Painting Three* 2010 (pl.*12*), one of a series of three, results from Hume's habit of zooming in and looking closely at specific areas of the body. Optically, the eye shifts between the central motif of the bird looking upwards and the more latent image of a woman's open legs, as the flesh-coloured 'background' comes into focus as thighs. An earlier series, collectively titled *American Tan* (pl.*13*), developed from a chance encounter with a billboard advert in New York featuring cheerleaders. Working from photographs of the billboard, and other images of cheerleaders in magazines, Hume characteristically focused on emblematic sections of the image such as the kicking legs and waving arms, removing traceable elements like a face. Artificial, consumer-friendly candy colours, alongside the ubiquitous synthetic beige tone of nylon tights, known as 'American Tan', are used to create strange, interlocking shapes that describe the young gymnastic bodies in action. In their occasional focus on the genital area, the paintings also capture the underlying sexuality that is an unspoken counterpart to the projected image of the wholesome American cheerleader. In a related work, *The Moon* 2009 (pl.*10*), an outstretched limb topped with a bright yellow pom-pom is transferred to a nocturnal setting, making the depicted body even less legible and more otherworldly. The painting merges elements lifted from seemingly separate realms – the disembodied body part is topped with a flower-like accessory, starkly depicted in contrasting colours silhouetted against the night sky.

What emerges in looking at over twenty-five years of Hume's work is the emotional intelligence with which he observes and then communicates in paint what are everyday yet extraordinary things, whether this is the anxiety projected by politicians trying to give order to economic chaos, the sexuality of a young female body or the conflicted emotions that determine all human relationships. Hume combines the 'no-nonsense' approach of Frank Stella, who declared, 'what you see is what you get'[20] referring to his own minimalist paintings made using industrial paints, with a restless desire to capture a sense of the world. Above all, Hume makes work that is satisfying in its completeness, deftly using composition, form and colour to create paintings that intrigue, pleasure and hold the eye.

1  'Ulrich Loock – Gary Hume. A Conversation', in *Gary Hume*, London 2009, p.6.

2  'David Sylvester Interview', in Kirk Varnedoe (ed.), *Jasper Johns: Writings, Sketchbook Notes, Interviews*, New York 1996, p.113.

3  The original template for the doors was found inside St Bartholomew's Hospital in East London during a period when it was run down and threatened with closure.

4  'Gary Hume in conversation with Caroline Douglas', in *Gary Hume: Flashback*, exh. cat., Southbank Centre, London 2012, p.27.

5  Various writers have quoted Hume describing his work as 'flora, fauna and portraiture'. For example, Rudolf Sagmeister, 'Endangered Beauty', in *Gary Hume: The Bird has a Yellow Beak*, exh. cat., Kunsthaus Bregenz, Bregenz 2004, p.78.

6  Adolf Loos's 1912 radical essay, 'Ornament and Crime', advocating a functional and rational style of architecture instead of the ornamental style of the Viennese Secession, an Austrian branch of Art Nouveau, became a highly influential text for the developing Modern Movement in art and architecture in this period.

7  Keith Hartley, 'I love Modernism, only I have no faith in it', in *Gary Hume*, exh. cat., Fundacio "La Caixa", Barcelona 2000, p.127.

8  David Barrett, 'Interview' in *Gary Hume*, New Art Up-Close 1, London 2004, p.5.

9  Adrian Searle, 'Behind the face of the door', in *Gary Hume*, exh. cat., British Pavilion, XLVIII Venice Biennale, British Council, London 1999, p.8.

10  *Auguries of Innocence*, first published c.1803.

11  Quoted in Benjamin H. D. Buchloh, *Andy Warhol's One-Dimensional Art: 1956–1966*, Cambridge, MA 2001, p.1.

12  Interview with Marcelo Spinelli, *Brilliant. New Art from London*, exh. cat., Walker Art Center, Minneapolis 1995, p.45.

13  'Ulrich Loock – Gary Hume. A Conversation', in *Gary Hume* 2009, p.9.

14  David Hickey, 'Gary Hume: Romance in the suburbs', in *Gary Hume: Flashback* 2012, p.11.

15  Barrett 2004, p.2.

16  Ibid., p.4.

17  Dominic Murphy, 'Gary Hume, Interview', *Guardian Weekend*, 7 Sept. 2002.

18  Ibid.

19  'Ulrich Loock – Gary Hume. A Conversation', in *Gary Hume* 2009, p.11.

20  Frank Stella, 'Questions to Stella and Judd', in Gregory Battcock (ed.), *Minimal Art: A Critical Anthology*, New York 1968, p.158.

You Hit Me with a Flower: The Art of Gary Hume    by Jack Bankowsky

I arrived at Gary Hume's Islington studio early last December to discover my sub-
ject halfway up a ladder, laying down what he hoped would be a final coat of paint
on a pair of oversize doors. The doors, he explained without breaking his practised
stroke, were conceived expressly for Tate, where they would replace the pair at
the entrance of the Linbury Galleries for the duration of this survey.

   'The doors will be the one trick I allow myself,' Hume apologised as he
descended his perch. That the panels are literally doors and not simply pictures
of doors as in the artist's early, reputation-making series, is the tricky part, of
course. And yet I grasped at once the artist's wager in risking a flourish he worried
might come off as a mere stunt: Hume was imagining the over-determined instant
when the museum-goer puts palms to the paintings and opens them onto the
artist's world within the galleries. If the 'trick' works, this instant of unseemly inti-
macy (Please don't touch the artwork!) will serve as a call to attention, italicising
the fragile pact that brings painter and viewer together at the picture plane.

      Inventing Gary Hume
The marvel of Gary Hume, of his self-invention as a painter, somewhat against
the grain of these intermedia times, resides in the fact that the crack his art
opened was all but invisible – until we fell into it. On paper, I would not have signed
up for the idea 'Gary Hume', and yet in the flesh (it is all about the flesh with
Hume) his art has felt inevitable to me since... it is hard now to recall exactly when.
This, of course, is the way it goes with decisive acts of artistic self-determination,
painterly or otherwise: they are impossible – and then they are bedrock.

   When did Hume become Hume? Most would argue that it was with the 'Doors',
the series that occupied the artist from the late 1980s to the early 1990s. (With
the exception of that one grand entryway flourish, the earlier series of 'Doors'
are excluded from this survey.) Hume came to art-making relatively late as these
things go. Having moved to London from Kent in 1978 at sixteen, with an as yet
unfocused drive to do something creative, he flailed about for a time, working in
film, an industry for which he quickly felt himself ill-suited. Faced with a 'need
to make things that did not need language or collaboration', he signed up for a
figure-drawing class. 'I found I loved it,' Hume said, 'that it was hard, that I was
getting better and that my drawings looked like mine.'[1] From there, it was on to
a stint as a landscapist, followed by a period of low-boil crisis during which he
struggled to turn the baseline pleasure he took in looking and making into some-
thing that might count as art. The turmoil begot a not-atypical student-period
hodgepodge: suits glued to canvas and slathered with paint; blood collected at a
slaughterhouse and injected between sheets of glass; Xeroxed photographs of
hamburgers affixed to canvases and doused with white paint, and then – Eureka!
– *Mushroom Door* 1988. With the first painting in the 'Door' series, Hume, by now a

Goldsmiths degree candidate, had landed something he felt to be his own. 'I was very pleased to have found [the doors as a subject] because they ticked so many boxes,' he recalled to Ulrich Loock in a 2009 interview. 'They addressed so many of the ideas that were prevalent at the time. They were clever works because I could paint, which is what I love to do.'[2]

A year after his epiphany and the deluge of paintings it precipitated, Hume took a detour. For some eighteen months, fearing his work had become a matter of mere sensibility, too light on its feet, he let others (a relative, a friend of a friend) choose the colours for his by-now signature compositions. The gambit was a throwback to an earlier way of thinking and proceeding; Hume rolls his eyes recalling the move today. Indeed, it was the turn just beyond this blind alley, when he reclaimed the reins and gave himself up unapologetically to his fate as an inspired – and utterly unpredictable – colourist, that remains more pertinent to the narrative of Humeian becoming. Today the 'Doors' feel definitive as a body of work as well as individually replete as paintings, an estimation that the ravishing survey accorded the series at Modern Art Oxford in 2008 made abundantly evident. And yet for me, Hume only became fully and irrevocably himself, when he left the 'Doors' behind, when he granted himself permission to step beyond the endgaming implicit in these early, pared-down variations, and dared the big 'fuck it' (the words are the artist's). This all-important leap of faith, the one that would shortly beget such altogether individual efforts as Adult 1994 and Bear 1994, was an amplification of that more modest 'fuck it', the one that allowed Hume fully to embrace the colour he had temporarily denied himself. It echoed the broader 'fuck it', the one that has permitted not just painting but art in general to escape the minimalist cul-de-sac and understand itself anew.

Of course, in hindsight the kernel of the Hume to come, Hume the audacious and wholly original picture maker, can already be glimpsed in the 'Doors', in the artist's insistence that they are images of doors rather than actual doors – or, more to the point, images as opposed to the purely formal arrangements they appear to be. As such, the series not only established Hume's commitment to the problem of picture making, to the interplay of representation and abstract invention, a terrain rendered off-limits by minimalism, they also, and tellingly, reveal the artist's distance from minimalism's apparent antidote. I am referring to the interdisciplinarity that characterises the broad-based intermedia turn in art, a tendency embodied locally for Hume in the work of, if not all the artist's YBA compatriots, then at least in that of the brand name's biggest fish – the Hirsts and the Emins. These are artists who hardly shy away from helping themselves to anything and everything their art demands. The 'Doors', then, speak of the course Hume set for himself as a painter and of the pressures he navigated as he made it his mandate to speak anew within the frame of that tradition.

### More Fucking Values

Hume, we know from early interviews, has claimed as twin enablers an unlikely pair of bedfellows, Donald Judd and Julian Schnabel. This assertion makes better sense if one recalls that, in the late 1980s, at the time Hume was emerging as an artist, Judd, the absolute minimalist, was revealing himself to be both a colourist (if of a certain sort) and a connoisseur of place and ritual architectures. Hume cites in Judd's late work an unanticipated 'spiritualism', a rabble-rousing word choice, but one for which we can forgive him, acknowledging the salient point that Judd's work demonstrated, by the end of that artist's run, an experiential richness we scarcely associate with minimalism's textbook purposes. As for Schnabel, he was much in discussion at that moment in a way that, while hard to appreciate today, makes the neo-expressionist's own, earlier 'fuck it', and the widespread 'return to the image' of which it partook, an understandable landmark for the young British artist.

It might, of course, be argued that Hume's early *détente* with modernism's more stringent negations had at least as much to do with the gambit of a Brice Marden (the 'Doors' recall the older artist's supple-surfaced arrangements of rectangular panels) or the relatively austere Ellsworth Kelly – or even Peter Halley, he of the denuded process and toxic palette – as with his advertised forefathers. The question for Hume (and this is where an artist like Halley comes in) was how to make a painting contemporary, a subset of the broader issue of how to make art equal to one's moment. In this respect, Hume shared the spirit – and ambition – of his YBA peers; he has even made it plain that his sense of kinship with his posse was so strong that he was scarcely cognisant of the fact that he was making relatively old-fashioned abstract paintings while his comrades were off stuffing sharks and mussing beds. The point, of course, was that Hume was not making old-fashioned paintings after all, but shiny new ones. And the mystery is how he managed this feat.

### Gary Hi-Gloss Hume

The New York art world of the 1980s, and particularly the artists grouped under the ill-fitting neologism neo-geo – Jeff Koons chief among them – cut the pass key that was then handed to the YBA generation, both with respect to a renewed interest in pop (and all that the high American-style pop of Warhol, Lichtenstein, Rosenquist et al. connotes) and a self-conscious relationship to the press, as a tool to be exploited and, in rarer cases, made a medium of one's art. I specify 'high American-style pop' to evoke the visual wallop of this type of 1980s artwork (and its near coincidence with the consumerist symptom), and thus to distinguish it from both the proto-pop of Hume's late 1950s to early 1960s compatriots and the art of those pop-culture-obsessed Americans that preceded the neo-geo phenomenon, artists who took our culture of the mass-mediated image as their subject matter as opposed to internalising its lessons. 'It was a great relief', Hume remembers of his neo-geo precursors, 'to be able to see things that did

7. Jeff Koons *Rabbit* 1986. Stainless steel, 104.1 × 48.3 × 30.5, The Eli and Edythe L. Broad Collection, Los Angeles
8. *Dolphin Painting I* 1990–1. Gloss paint on four panels 218 × 590, Private collection

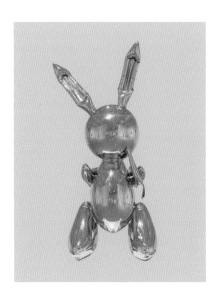

not rely upon the artist's faith in their own value judgments... Rather than having to put your sack cloth on to describe it [the world],' he says with the identity- and media-critical art of the 1970s in mind, 'you actually put your queen's robe on – your Freddie Mercury robe.'[3]

Both neo-geo and the YBAs were products of their moments: if neo-geo registered the first tremors of the furiously expanding art market and the attendant (and unprecedented) interest taken by the media in all matters art world, the YBAs arrived just in time to stoke the embers and see them fire anew. When Hume says that it is next to impossible to overestimate the enabling role the New York exemplars played for the YBA generation, he does so in a gently self-deprecating manner, summoning 'both... the Thatcherite and punk', the 'pull-up-your-own-socks' nature of his peer group's DIY careerism.[4] What is more crucial to this discussion, however, is the will revealed in Hume's sense of immediate ancestry to forge an art that might hope to equal that glistening imponderable – Jeff Koons's *Rabbit* 1986 (fig.7) – in the medium of painting! Iain Gale, writing in the *Independent* in 1995, quipped that 'Hume is a protégé of the arch art marketeer Jay Jopling. Having wowed us with Damien "the sheep" Hirst and Mark "blood head" Quinn, Jopling now presents Gary "hi-gloss" Hume.' These words bear repeating not only because they recall once again how central Hume was to the YBA explosion but because they underscore the fact that he managed to make his mark by producing paintings – paintings that seemed, to the journeyman journalist, self-evidently at home among the most stridently, even abrasively contemporary art of the moment.[5]

### Old Europe

When it comes to the problem of how to make a painting contemporary, others have travelled the same road before: Patrick Caulfield, the subject of an exhibition at Tate intentionally timed to coincide with Hume's, is a resonant case in point. Like Hume, Caulfield was fully alive to the fact that, if he was to recuperate the pictorial poise wherein the conventional genre protocols of, say, still life remain a control against which abstract invention becomes legible as such (a poise associated with, for instance, the early modern moment of Cubism), he would need to find a way to make the proposition contemporary. For Caulfield, placing a plate of photorealist chicken inside a Stuart Davis-like still life lets us savour once more the pleasures of pictorial complexity while (ironically, given the gesture's playfulness) permitting us to take Caulfield's own modernity seriously. For American pop master Roy Lichtenstein – a painter most would agree succeeded in 'making it new' – it was the funny papers and the Ben-Day dot from which they were constructed that made picture-making possible again, allowing him to repaint Picassos. For Hume, the magic ingredient was Old Europe house paint (a brand much preferred by high-end decorators).[6] How could out-of-the-can enamel be made to bear such a cultural load? There is, after all, nothing new in a fine artist resorting to the industrial cousin of oil paint – think of Willem de Kooning

or Frank Stella – and yet at the end of Hume's brush, house paint has never felt so absolutely itself, so glossy, so interiors-magazine luxuriant. In a work from the 'Doors' series like the multi-panelled nocturne *Dolphin Painting I* 1990–1 (fig.8), the sheen is so high that the body-scaled arrangement of painted portals functions as a virtual hall of mirrors, bringing the viewer's reflection into the picture.

The seeds of Hume's 'return to picture making' were just that, seeds. For all their success, the 'Doors' were still, for all intents and purposes, minimal paintings, and the year or so immediately following their four-year run found the artist struggling to secure his footing in a newly liberated terrain. A work like *Jealousy and Passion* 1993 (fig.9), in which Hume collaged a pair of photographic lips clipped from a woman's magazine onto an otherwise abstracted figure, functions as a kind of 'it could go as far as this' when it comes to the degree of representational verisimilitude he might admit to a painting. If the gesture recalls de Kooning's precedent (the abstract expressionist famously affixed a series of cut-out mouths to *Women I* in the process of creating this landmark work), Hume's painting was his hello to the figure, whereas de Kooning, by the time he glued a smile atop his slashing, gnashing, female archetypes, was already saying so-long to the likeness on the way to his progressively more abstract art. What's more, in Hume's case, the figure is male – a silhouette, suggesting a cocksure posture, inspired by the fascist statuary encircling the Mussolini Olympic stadium that he saw on a 1993 visit to Rome. Festooned with a few flower-power blooms that look ahead to one of Hume's signature motifs, *Jealousy and Passion*, like the other works in the series – including the well-known *Vicious* 1994 – flaunts (even spoofs) the artist's newly felt power. If authoritative efforts such as these are punctuated by less confident negotiations of the ecology of image and abstraction, we are by this time but a heart-beat away from *Adult*. By 1993, Hume is sailing full into the wind.

Good Hair Day

In situating Hume's art, Dave Hickey has spoken of an 'avuncular armistice' in 'the war between abstraction and figuration', aligning him with a group of artists (Caulfield, Ellsworth Kelly, Alex Katz, Ken Price and John Wesley) that he dubs 'the abstractionists of daily life'.[7] In Hickey's formulation a cross-current running against the high-abstraction mainstream, the art of each of these figures – quotidian in reference, cosy (at least compared to, say, an Ad Reinhardt), bound to the referent but with important abstract qualities – maintains affinities with Hume's own. Yet despite the model's usefulness, Hickey's parsing of the field is in at least one respect too wilful: Kelly, whom the critic would rescue from his status as 'mandarin abstractionist' in order to align him with this plain-spoken posse (on grounds, one assumes, that the manifestly abstract relationships in his paintings are typically derived from observed nature), is not entirely at home in this company. This is a hair worth splitting, if only because for me it is the example of Kelly that most aptly sheds light on how a painting by Hume actually works. Kelly's sources in the world (at least in his paintings) are so boiled down to abstract essentials that they

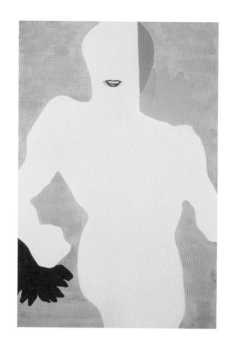

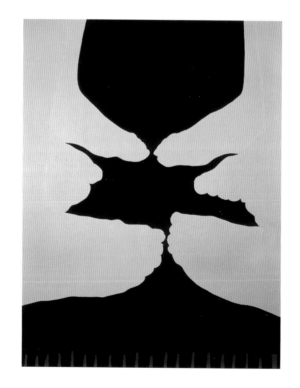

typically cannot be recognised without coaching, which is to say that he may as well be the mandarin abstractionist that Hickey would revise. This is not the case with Hume, of course, and yet, the balance of the younger artist's work always tips for me toward the abstract. A painting like *Four Feet in the Garden* 1995 (fig.10), recalls Wesley, but it is relatively rare in Hume's oeuvre that an image relies so heavily on anecdotal whimsy, and the sort of attention to milieu one finds in, for instance, Katz's social studies is altogether foreign to Hume's art.

Just how subject matter, manifest or less so, does finally work in Hume's art is a knotty question. A masterwork like *Green Nicola* 2003 (pl.11) is not simply about a girl with major hair – at least not in the way a Wesley might have been. Instead, the abundant mane functions foremost as abstract incident, its anecdotal interest strictly secondary to the formal labour it is made to do. Indeed, *Green Nicola,* which is mostly yellow, stands or falls on several inspired and altogether disarming formal moves. To begin with, the yellow hair, which fills a good two thirds of the painting and is signalled as such by a series of 'hair lines' scratched though the paint to reveal the aluminium support, is improbably set against a like-coloured ground. The only thing that differentiates it from the dominant tresses is the absence of incised lines and a hint of brushwork. The enveloping, almost-overall yellow brackets a deep olive sliver of face, which is sharply divided in two at just about the spot where one would expect to discover the lower lip. Brushed in a pale pink that extends from the chin down the narrow rivulet of torso visible through the curtain of blond, the chin jumps to the picture plane, and the facial features, discernible when etched through the swamp-green upper face, disappear when they hit the lightened chin as the value contrast that makes them prominent is here missing. The relationship of colour to the representational task at hand (depicting a face) is counterintuitive by any standard – except that of visual excitement.

Close formal readings of this sort, I am well aware, are the sleeping pill's stiffest competition, but I hazard the tedium to make the point: the formal vitality of a work like *Green Nicola* is so highly pitched that to make the visual ingenuity a mere handmaiden to expressive ends and to consume the painting as, say, a cartoon of a shy woman who employs her locks as worldly armour seems decidedly misguided. And yet having so insisted on the primacy of form, I must backpedal, if cautiously: not only does the painting's abstract ingenuity depend on the fact that we hold the figural reference in the balance – hair, facial features and the conventions of representing each provide ballast against which what is detailed and what is glossed, what is spatially pushed or pulled, is made legible – but we do (and I hesitate to overplay this) finally experience the sitter's symptom, her vulnerabilities and the seductions that come with them. This is bound up in some difficult-to-pinpoint way with the fact that the dark orifice of frightened face set in its nest of hair lends a decidedly sexualised undercurrent to the whole affair.

The dynamic between form and affect in Hume's art is a matter of some per-plexity to me – and clearly to the artist as well, whose contradictory sentiments capture the conundrum perfectly: 'The original image is actually just a bunch of

9. *Jealousy and Passion* 1993. Gloss paint, pencil and cardboard on panel, 201 × 133, Private collection
10. *Four Feet in the Garden* 1995. Gloss paint on aluminium, 221 × 172, Arts Council Collection

forms from within which I can find the painting. It's useful to me, and it might actually hold the meaning of the painting finally, but it bears no relation to the painting itself.'[8] Of *Young Mother and Child* 2001 (pl.3), a pet painting for Hume, he notes with apparent satisfaction that 'I nailed the emotion in that one,' then stops himself short. 'I am not even trying to put it [emotion] into the other ones,' he muses aloud, then exclaims, as if to throw up his hands, 'Well, then what exactly am I doing?' It's the 'finally' in the comment above (even if Hume doubly undercuts himself) that gives me pause. When it comes to the way the abstract and the representational combine in Hume's work, I initially look by way of analogy to the art of Matisse, where the referent matters but not fundamentally so (and only as a stand-in for the 'of something' that makes the painting a depiction), but the comparison is not entirely apposite. Perhaps it is Picasso, Matisse's less gentle rival, who provides the truer model. In the latter's art, abstract qualities are once again keyed to a pitch that can make them seem the whole story, and yet the fraught side of human experience – love, war and death – is not only present but presumably generative. Whether such putative subject matter finally 'holds the meaning of the painting' for either artist, I cannot say.

On the one hand, Hume gravitates to big themes and to loaded symptoms – sex and death and malignant stardom. Flaws and failure are his stated métier. And yet how can we square his choice of Michael Jackson, the *monstre sacra* at the dark heart of modern celebrity, as a portrait subject, or his fascination with the authorised White House photograph of Barack Obama and members of his cabinet viewing the death of Osama Bin Laden that precipitated the history-painting-scaled *Anxiety and the Horse* 2011, with his mainstay flowers and birds? Is there a thread connecting Hume's subject choices, a unifying principle behind the apparently promiscuous agglomeration of subjects and pre-existing images on which his attention alights? And can we decode the alchemy whereby the 'painting part' takes over the 'subject matter part' and turns raw life into artistic gold?

In *Michael* 2001 (fig.11), the 'abstraction' seems marshalled to capture the look and spirit of his quarry with each formal decision, including the tondo shape, dictated by the subject. Indeed, the person who inspired the work is so vividly and indelibly an ingredient in the end product that, if it fell to me to preserve a single likeness of the star-crossed star to pass down to the future, Hume's portrait would be my choice. By contrast, the Bin Laden news photo (and the world-historical moment it pictured) that inspired *Anxiety and the Horse* are so fully sublimated in Hume's artistic end product that one would never guess its locus without the aid of further literature. Indeed the artist, as dumbfounded as the viewer by the nature of his transcription, or better transformation, has owned that he denounced himself on surveying the finished painting: 'you're absolutely kidding me. This just looks like a bunch of balloons going across a field.'[9]

Both paintings are of course weighted to opposite extremes when it comes to the form/content equation in Hume's work. Each is in this respect exceptional in an oeuvre that includes every degree of abstractedness in between. Focusing only on

11. *Michael* 2001. Gloss paint on aluminium, 122 diameter, Private collection
12. *Exclamation Point 1* 2004. Gloss paint on aluminium, 61 × 33, Private collection

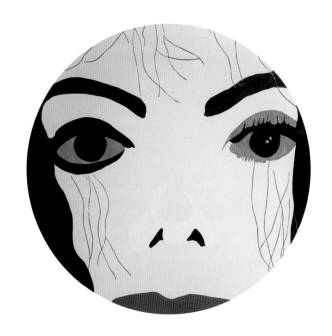

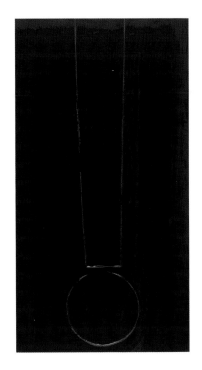

the 'portraits', the English painter Francis Bacon (*Francis* 1997) shows up looking a lot like himself, all cartoon *terribilità*; the artist's mother by contrast is elegantly abstracted in *Green Hat* 2002, where the stark white arc of her collar and a fully abstract band of green – the titular hat – get equal billing with the grey-on-black shadow of her dress; and finally supermodel Kate Moss, who makes two separate appearances in Hume's oeuvre, is all but disappeared by the time she shows up in the prodigiously ugly tondo *Beautiful* 2002 (pl.*1*), her bankable features drowned in the painting's foundation-pink surface, with an abstracted view of Jackson's nose, famously mangled by cosmetic surgery, superimposed on top of her perfect one.

I want a rule, but the truth is that Hume's painting functions in various, sometimes contradictory, ways. And yet for all the disparateness of his themes and of the transpositions to which he subjects them, what his paintings might be said to have in common – and this I think is absolutely significant – has to do with the fact that he keeps close to the baseline perplexities of seeing and depicting. That is, his subjects (often images already in the world) attract Hume not just because he sees in them some formal opportunity – a visual dynamic to exploit (pace Kelly) – or because they originate in some real-world urgency. Rather, such formal opportunities and life conundrums are inseparable for him from the problem of *re-*presenting, of making a picture in the first place, an observation that may shed some light on not only what makes for a Hume but for a good Hume. Not every subject that excites, he has pointed out himself, is a good *painting* subject, which explains why *Green Nicola* or *Michael* or *Beautiful* are stunning achievements while *Anxiety and the Horse* remains a relatively fraught experiment.

### Black is Beautiful
*Beautiful* is a good Hume because his subject – 'the supermodel Kate Moss', or rather the problem of beauty that her famous face embodies – is also, in a funny way, his problem as a painter. 'Kate', the artist has commented, 'was already an image; she had this magical ability to transform herself from a three-dimensional person to a two-dimensional one the moment she stepped in front of a camera', which is what made Moss, the rise of her waif look, a durable perplexity for him. What we take for beautiful has a way of flip-flopping on itself, and in this painting the conventions of beauty as they modulate in the look books of the fashion industry find an analogy in the more rarefied realm of artistic style. It was, of course, Jackson's quixotic quest for beauty, his maniacal determination to make a black nose white, that turned this brightest of child stars into a latter-day Frankenstein.

*Beautiful*, the reader may well protest, is exceptional rather than representative in Hume's oeuvre. And yet it seems to me that its meld of subject matter and artistic problematic is in fact discoverable across his output, if in guises various enough to be, in the first instance, unrecognisable as kin. Take for instance Hume's attention to flowers and birds (pl.*14* and *6*), subjects with none of the social-cultural resonance of a zeitgeist emanation like Moss. Here it is the generic subject choices – the fact that they are so Hallmark-card neutral as to announce themselves first as

13. *Hero* 1993. Gloss paint on panel, 201 × 133, Private collection
14. *She* 1999. Gloss paint on aluminium, 300 × 244, Private collection

imagistic clichés – that keep us close to the fact that we are trafficking in pictures, that indeed Hume's problem is picture making as such. It is only in tension with these evacuated templates that a work like *The Whole World* 2011 (pl.4) delivers up its monstrous luxuriance. The same daffy, default-mode is at work in paintings like *Snip* 2004 and *Bird on a Branch* 1998, providing a degree zero of significance against which a next-to-nothing formal move becomes the fulcrum of a pictorial tour de force. In *Snip*, a tiny, pale yellow disc at the picture's centre, representing the thickness of the cut flower stem, is the *punctum* that turns a two-dimensional pattern into a three-dimensional illusion. Similarly, the Simple Simon drawing in *Bird on a Branch,* executed in yellow on a close-valued lavender ground, so buzzes as a result of value equivalence and colour complementarity that the image threatens to evanesce before our eyes. Here a tiny section of branch traced over in a deeper maroonish brown plays an analogous role to that of the little yellow pill in *Snip*; it's the pivot on which the image turns inside out. At first glance this darker-valued grace note is virtually all one sees through the chromatic buzz, but as we rub our eyes the avian cipher comes into focus. On paper these 'tricks' may sound too clever by half, but in the flesh they are diabolical, if ironically so, as Hume's tool kit, being medium-specific, in the final analysis includes no smoke or mirrors.

The 'Exclamation Points' (fig.12) are as different from birds and flowers as the latter are from a supermodel, and yet once more it is the baseline representational conundrum that is generative. Call it the Jasper Johns effect: as with a flag or a number, a picture of an exclamation point is also an exclamation point, the thing itself and its representation being one and the same. Though realised in grisaille – or even all out black-on-black – these paintings are made so colourful in Hume's hand, one longs to lick them like the lollipops the images notionally resemble.

Hume is a wholly original colourist, and one might easily squander paragraphs attempting to describe the indescribable tertiary chartreuse in *Woman with Sash* 2003, or celebrating the colouristic pluck behind *Three Apples*, a painting realised the same year that counterintuitively sticks to the blue end of the colour spectrum (teal apples on a differently valued teal ground) to achieve its gorgeous throb. Given the embarrassment of colouristic riches in Hume's art, it might seem perverse to dally in the straightened precincts of basic black, if not for the fact that Hume has a decided penchant for the colour of mourning – and bohemian chic. His oeuvre includes no fewer than two dozen paintings that are ostensibly all black, and there are as many works again in which, while whites and greys may play supporting rolls, black remains the star. Indeed, having visited the Guggenheim exhibition devoted to Picasso's black and white work just as I was collecting my thoughts for this essay, it occurred to me that Hume might be equally well served by such a survey. Hume puts black through its paces, exploiting not only its colouristic range but tapping its poetic and metaphoric resonances, including, to his own initial consternation, the unavoidable association of race.

*Blackbird* 1998 (pl.6), a work whose protagonist is in fact dark blue, is in the latter respect unencumbered; the relationship of the titular colour to its avian

sitter remains wholly local to the realm of pictorial (and linguistic) play. *Snowman*, Hume's 1997 photograph (and the prototype for his ongoing sculpture series) on the other hand, has an extra formal dimension: dirtied, the way snow typically gets a day after a fresh fall, it looks ahead to the absolute, abstract black of *Back of a Snowman* 2002, another perfectly Humeian image of an image in which the non-colour is an essential ingredient in the mix of meaning. Finally there is *Baby* 1994–5 (pl.*22*) that masterwork among the black paintings: Hume knew of course when he painted *Baby* that he was making a black (as in the colour) picture, but it was not until he stepped back to gaze on what he had wrought, that the other shoe came down: 'What is that totally petrifying black [as in race] baby?' he asked his flummoxed self. 'Is it a positive black baby? Is it a negative black baby? Is it just a black baby?' Inspired by a dad's-eye view on a cradled newborn, by the creature's mewling alienness, Hume can laugh at his own unconscious, off-colour doubling of the default mode trope for 'othernesses'. He has never been unduly cautious when it comes to the active thought bomb, and at moments he has been Hurt-Locker reckless, as, for instance, he was in *Jew* 2007, a painting in which the word itself, rendered in fully lustrous sapphire disappears into its same-coloured ground. I follow this thread not because I believe this ten-tonne Ed Ruscha is among his strongest works but because it speaks to a certain dare-devil recklessness when it comes to keeping his painting real. Hume has said that 'The great disappointment of making anything is that it's not everything, and you'd love to make it everything'; *Jew* represents the artist reaching for more perhaps than the painting can hope to deliver. Its success would depend on looping the violence implicit in any representation into the knot of form and meaning that in his best work is seldom this easy to untangle.

How lame, after 5000 words, to drop this hot potato and conclude with a painting that I am certain 'works', that indeed I count among my very favourites. *American Tan IX* 2006–7 (pl.*13*) may not tie the bow of form and meaning as elegantly as a *Beautiful* or a *Baby*; it does not boast the indelible iconicity of a *Michael* or the titillating poise, at once scare quoted and unapologetically sensual, of a Humeian flower or puff of smoke. Why then my infatuation? It can't just be the rear view vantage on the sitter or her perfunctory, too-unexceptional-to-notice posture? Perhaps it is the two together? Is it the black-on-black head or the blunt all-ochre torso? More likely it's the way the two sharply abut at the severed neck of a horizon. Can the whiff of surrealism that causes the black hole of a head to oscillate between tree canopy and wig have anything to do with this painting's spell? Or does it all come down to the formal economy of two colours and three shapes (one being the background), an arrangement I will admit simply sends me. That *American Tan IX* is all of these things and yet none of it quite adds up – except that in the flesh it finally does – will recommend it to me when I reach for a postcard in the gift-shop queue – and guarantee it a spot on the wall-without-walls above my desk, where the hang may be casual but the art is strictly A list.

1 Except where stated all quotes
are from interviews with the
author between October 2012
and February 2013.

2 'Ulrich Loock – Gary Hume:
A Conversation', in *Gary Hume*,
London 2009, p.6.

3 Ibid., pp.7–8.

4 Ibid., p.7.

5 Iain Gale, 'So slick, so appealing',
*Independent*, 12 Sept. 1995.
http://www.independent.co.uk/
arts-entertainment/so-slick-
so-appealing-1600688.html,
accessed 5 Dec. 2012.

6 When working on his paintings
in the United States, Hume uses
the paint brand Old Europe;
he uses Dulux when working
in the UK.

7 Dave Hickey, 'Will Heather Be
There?' in *Gary Hume: Yardwork*,
exh. cat., Matthew Marks Gallery,
New York 2009, p.8.

8 'Ulrich Loock – Gary Hume:
A Conversation', in *Gary Hume*
2009, p.9.

9 Quoted in Mathew Marks Gallery
press release, *Gary Hume: Anxiety
and the Horse*, 5 May–23 June
2012. http://www.matthewmarks.
com/new-york/exhibitions/2012-
05-05_gary-hume, accessed
21 Jan. 2013.

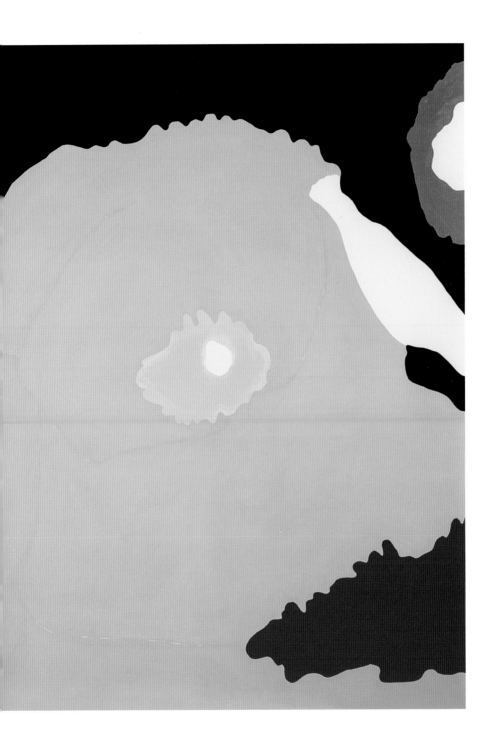

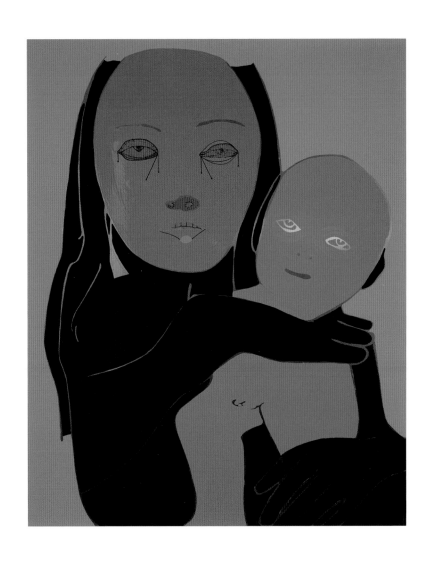

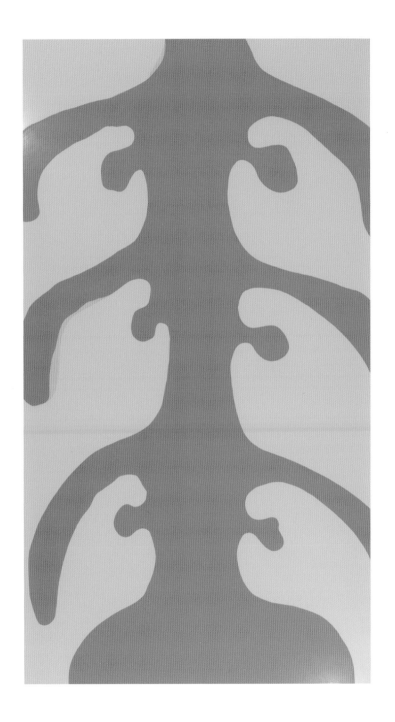

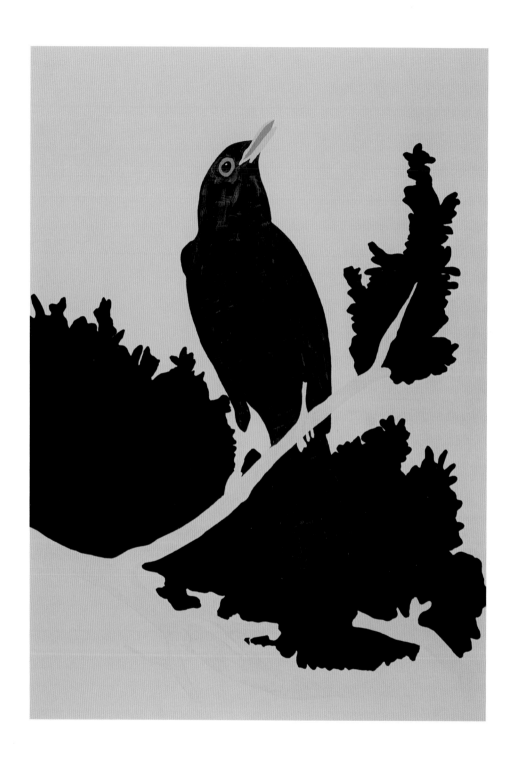

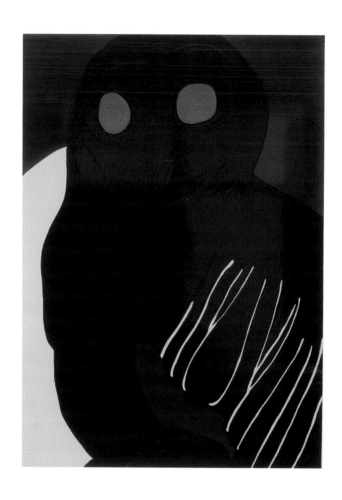

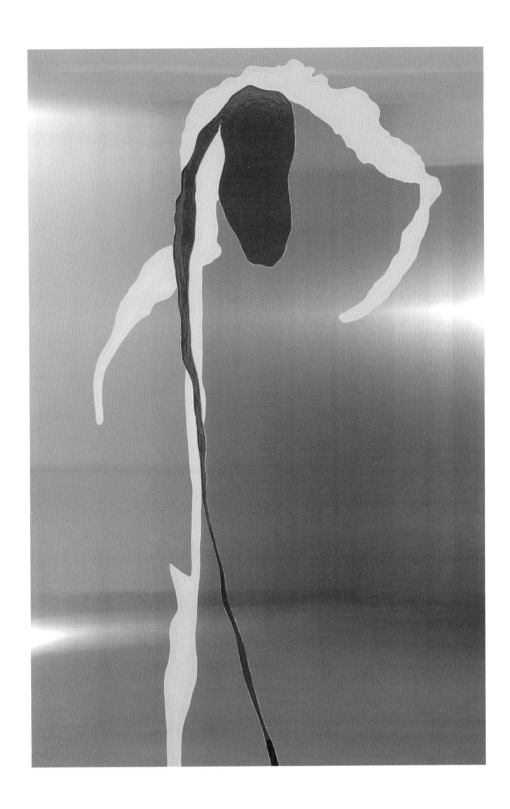

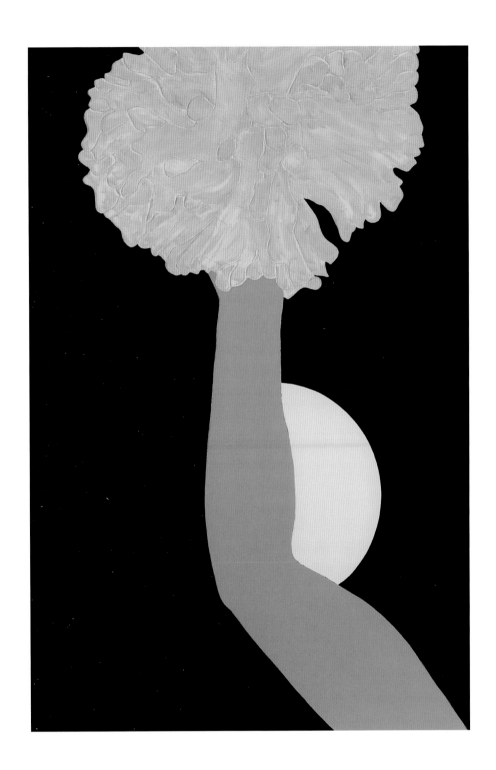

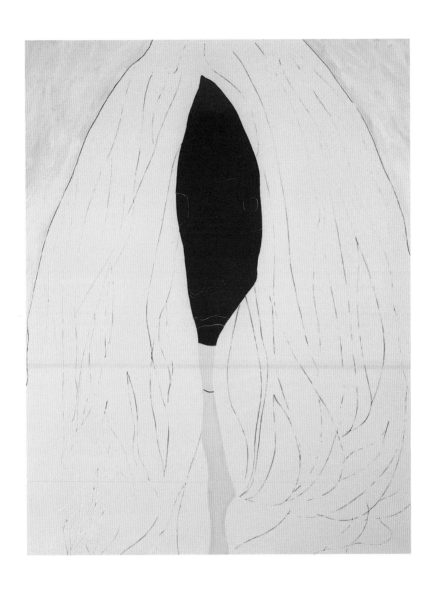

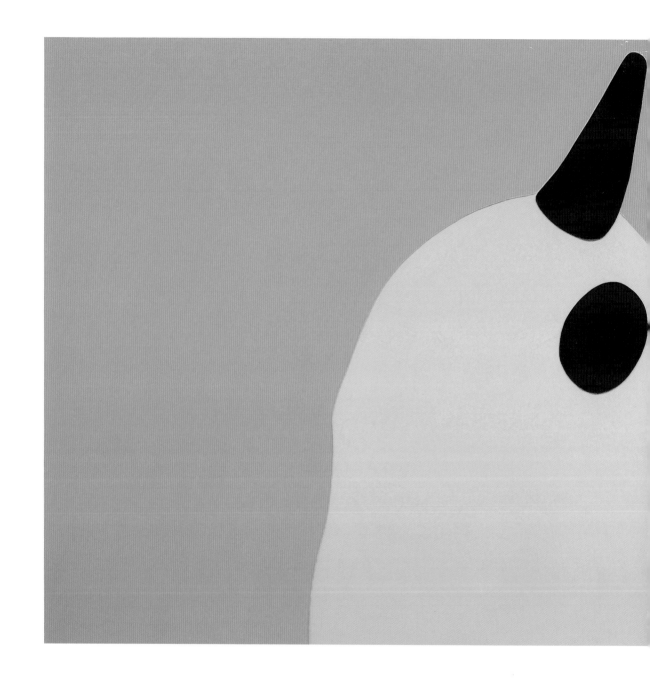

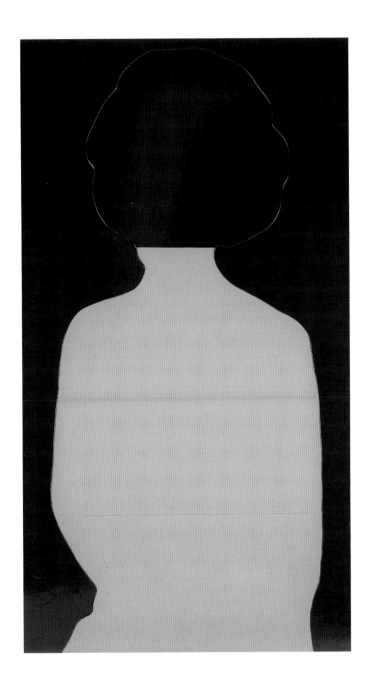

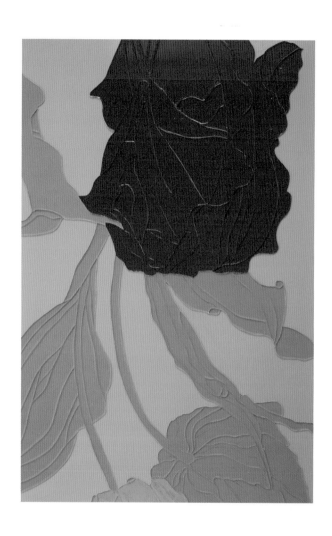

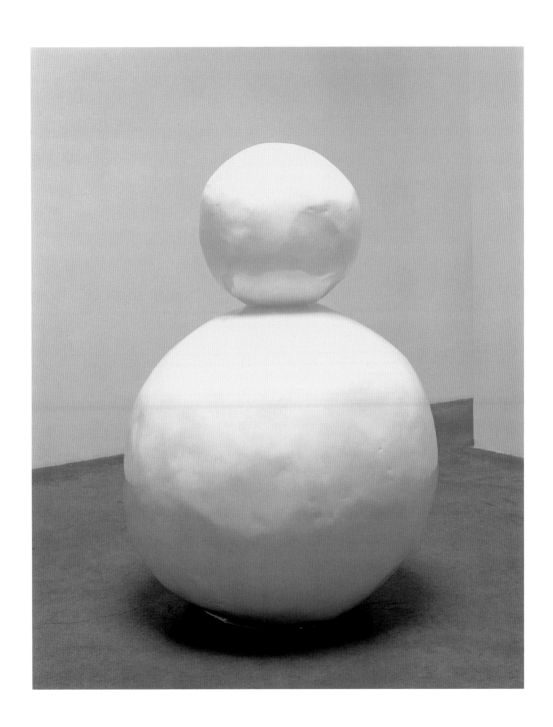

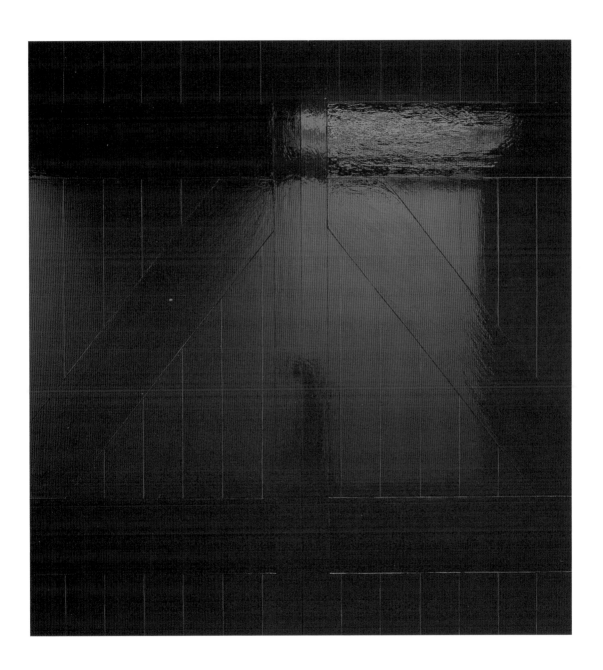

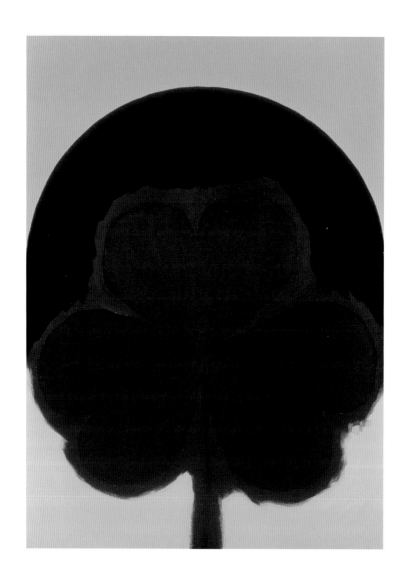

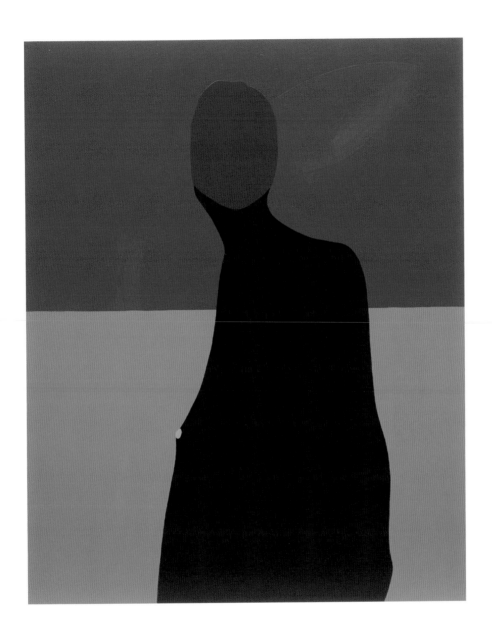

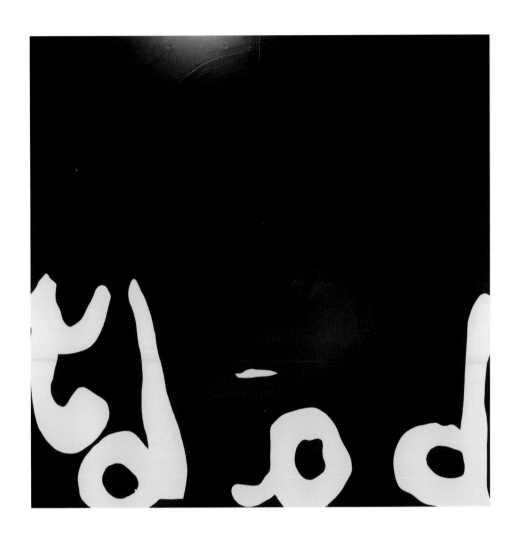

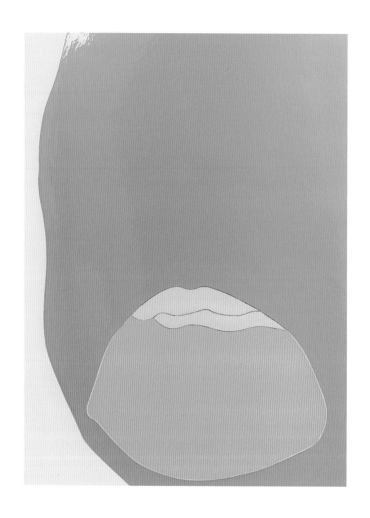

# List of Works

Unless otherwise indicated,
all works © the artist

*How to paint a door* 2013
Gloss paint on modified
gallery door
319 × 236
Private collection
Illustrated pp.3–7

1 *Beautiful* 2002
Gloss paint on aluminium
117 diameter
Frank Gallipoli

2 *Innocence and Stupidity* 1996
Gloss paint on two aluminium
panels
Each 221 × 170
Bonnefantenmuseum Maastricht

3 *Young Mother and Child* 2001
Gloss paint on aluminium
153 × 122
Cranford Collection

4 *The Whole World* 2011
Gloss paint on aluminium
183 × 145
Courtesy of PinchukArtCentre
(Kiev, Ukraine)

5 *Birdsong* 1998
Gloss paint on aluminium
209 × 117
Private collection, London

6 *Blackbird* 1998
Gloss paint on aluminium
234 × 164
Private collection, London

7 *Two Minds* 2001
Gloss paint on aluminium
254 × 163
Rashid and Lucy Hoosenally

8 *The Moon* 2002
Gloss paint on aluminium
138 × 99
Private collection, Austria

9 *Nicola as an Orchid* 2004
Enamel paint on aluminium
256 × 168
Matthew Marks Gallery

10 *The Moon* 2009
Gloss paint on aluminium
244 × 161
Collection Marie-Aline
and Jean-François Prat

11 *Green Nicola* 2003
Gloss paint on aluminium
180 × 139
Private collection

12 *Paradise Painting Three* 2010
Gloss paint on aluminium
198 × 386
Courtesy of the artist
and White Cube

13 *American Tan IX* 2006–7
Gloss paint on aluminium
208 × 117
Ayman and Sawsan Asfari

14 *Tulips* 2009
Enamel paint on aluminium
161 × 106
Private collection, courtesy
Matthew Marks Gallery

15 *Garden Painting #3* 1996
Gloss paint on aluminium
198 × 150
Kunstmuseum Wolfsburg

16 *Back of a Snowman (White)* 2000
Enamel paint on bronze
152 × 124 × 44
Private collection

17 *Red Barn Door* 2008
Enamel paint on two aluminium
panels
Each 282 × 132
Tate. Purchased with funds
provided by Samuel and Nina
Wisnia and the Art Fund 2012

18 *Tony Blackburn* 1993
Gloss and matt paint on panel
193 × 137
Private collection

19 *Older* 2002
Gloss paint on aluminium
200 × 163
Private collection

20 *The Cradle* 2011
Gloss paint on aluminium
198 × 196
Private collection

21 *Yellow Window* 2002
Gloss paint on aluminium
135 × 98
Private collection, London

22 *Baby* 1994–5
Gloss paint on aluminium
173 × 173
Lorcan O'Neill

23 *Anxiety and the Horse.
Angela Merkel* 2011
Enamel paint on aluminum
152 × 112
Private collection, courtesy
Matthew Marks Gallery

# Gary Hume

Gary Hume was born in Kent in 1962 and graduated from
Goldsmiths College, London in 1988 the same year he
took part in the second Freeze exhibition at Surrey Docks.
In 1996 he was shortlisted for the Turner Prize at the Tate
Gallery and was awarded the Jerwood Painting Prize in
1997. Hume represented Britain at the São Paulo Biennial
in 1996 and the Venice Biennale in 1999, and was elected
as a Royal Academician in 2001. He lives and works
in London and Accord, New York.

## Selected Solo Exhibitions

### 2012

*Gary Hume: Flashback*, Leeds Art Gallery; Wolverhampton Art Gallery; Jerwood Gallery, Hastings; Aberdeen Art Gallery

*2*, Sprüth Magers, Berlin

*Gary Hume: Anxiety and the Horse*, Matthew Marks Gallery, New York

*Gary Hume: The Indifferent Owl*, White Cube, London

*Gary Hume: Beauty*, PinchukArtCentre, Kiev

### 2010

*Gary Hume: New Work*, New Art Centre, Roche Court, East Winterslow

*Bird in a Fish Tank*, Sprüth Magers, Berlin

### 2008

*Gary Hume: Door Paintings*, Modern Art Oxford

*Baby Birds and Things That Are Left Behind*, Galleria Lorcan O'Neill, Rome

### 2007

*American Tan*, White Cube, London

### 2006

*Cave Paintings*, White Cube, London

### 2004

*Carnival*, Kestnergesellschaft Hannover; Matthew Marks Gallery, New York (2005)

*The Bird has a Yellow Beak*, Kunsthaus Bregenz

### 2003

*Gary Hume*, Irish Museum of Modern Art, Dublin

### 2000

*Gary Hume*: *Culturgest*, UMA Casa do Mundo, Lisbon; Fundació "la Caixa", Barcelona

### 1999

*Gary Hume*, Whitechapel Art Gallery, London

*Gary Hume*, Scottish National Gallery of Modern Art, Dean Gallery, Edinburgh

*Gary Hume*, British Pavilion, 48th Venice Biennale

### 1998

*Turnaround: Inside Out at the Hayward*, Hayward Gallery, London

*Gary Hume: Small Paintings*, Matthew Marks Gallery, New York

### 1996

*Gary Hume*, Bonnefantenmuseum, Maastricht

*Gary Hume*, 23rd São Paulo Biennial

### 1995

*Gary Hume*, White Cube, London

*Gary Hume*, Kunsthalle, Bern; Institute of Contemporary Arts, London; Spacex, Exeter

### 1992

*Recent Paintings*, Matthew Marks Gallery, New York

### 1989

*Gary Hume: Recent Works*, Karsten Schubert Ltd., London

## Selected Group Exhibitions

### 2012

*A House of Leaves. Second Movement*, David Roberts
Art Foundation, London

*Summer Exhibition 2012*, Royal Academy of Arts, London

### 2011

*Collection Platform 1: Circulation*, PinchukArtCentre, Kiev

*Structure and Absence*, White Cube, London

### 2010

*Kupferstichkabinett: Between Thought and Action*,
White Cube, London

### 2009

*WE ARE THE WORLD: Figures & Portraits*, Fisher
Landau Center for Art, New York

### 2008

*Art Is For The Spirit: Works from the UBS Art Collection*,
Mori Art Museum, Tokyo

*Pretty Ugly*, Maccarone and Gavin Brown's
Enterprise, New York

### 2006

*Liquid: Gary Hume & Lynette Yiadom-Boakye*,
Royal Academy Schools, London

*Aftershock: Contemporary British Art 1990–2006*,
Guangdong Museum of Art, Guangzhou; Capital
Museum, Beijing (2006–7)

### 2004

*The Flower as Image: From Monet to Jeff Koons*,
Louisiana Museum of Modern Art, Denmark

*Edge of the Real*, Whitechapel Art Gallery, London

*Art of the Garden*, Tate Britain, London

### 2003

*Supernova: Art of the 1990s from the Logan Collection*,
San Francisco Museum of Modern Art

### 2002

*Remix: Contemporary Art and Pop*, Tate Liverpool

*Painting on the Move*, Kunstmuseum, Museum für
Gegenwartskunst and Kunsthalle Basel

### 2001

*Collaborations with Parkett: 1984 to Now*, The Museum
of Modern Art, New York

*Century City*, Tate Modern, London

*Spy*, Monika Sprüth Magers, Cologne

### 2000

*Painting the Century: 101 Portrait Masterpieces
1900–2000*, National Portrait Gallery, London

*Sincerely Yours, British Art from the 90s*, Astrup
Fearnley Museum of Modern Art, Oslo

### 1999

*Trace and Art Lovers*, Liverpool Biennial of Contemporary
Art, Compton House, Liverpool

*Graphic! British Prints Now*, Yale Center for British Art,
Yale University, New Haven

### 1998

*Thinking Aloud*, Kettle's Yard, Cambridge; Cornerhouse,
Manchester; Camden Arts Centre, London

*Real/Life: New British Art*, British Council Touring
Exhibition, Tochigi Prefectural Museum of Fine Arts

*The Janet Wolfson de Botton Gift*, Tate Gallery, London

### 1997

*Jerwood Painting Prize 1997*, Lethaby Galleries,
Central St Martin's College of Art and Design, London

*Sensation*, Royal Academy of Arts, London; Hamburger
Bahnhof, Berlin (1998–9); Brooklyn Museum, New York
(1999–2000)

*Young British Artists*, Saatchi Gallery, London

### 1996

*Turner Prize 1996*, Tate Gallery, London

*About Vision: New British Painting in the 1990s*,
Museum of Modern Art, Oxford; Fruitmarket Gallery,
Edinburgh; Wolsey Art Gallery, Ipswich

*Full House: Young British Art*, Kunstmuseum, Wolfsburg

*A Small Shifting Sphere of Serious Culture*, Institute
of Contemporary Arts, London